BRITISH TRADEMARKS of the 1920s & 1930s

BRITISH TRADEMARKS of the 1920s & 1930s

by John Mendenhall

ANGUS
& ROBERTSON
PUBLISHERS

Angus & Robertson Publishers
16 Golden Square, London WIR 4BN,
United Kingdom and
Unit 4, Eden Park, 31 Waterloo Road,
North Ryde, NSW, Australia 2113

The trademarks are reproduced in colors typical of the era,
not necessarily those originally used. Where exact dates of
registration are not available, approximate dates for the
marks have been given.

First published in the United Kingdom by
Angus & Robertson (UK) in 1989
First published in Australia by
Angus & Robertson Publishers in 1990
First published in the United States
by Chronicle Books in 1989.

©1989 by John Mendenhall

Printed in Japan.

British Library Cataloguing-in-Publication Data

Mendenhall, John
British trademarks of the 1920s and 1930s.
1. Great Britain. Trademarks, history
1. Title
602'. 73

ISBN 0-207-16467-3

Dedication

For Karl and Miriam

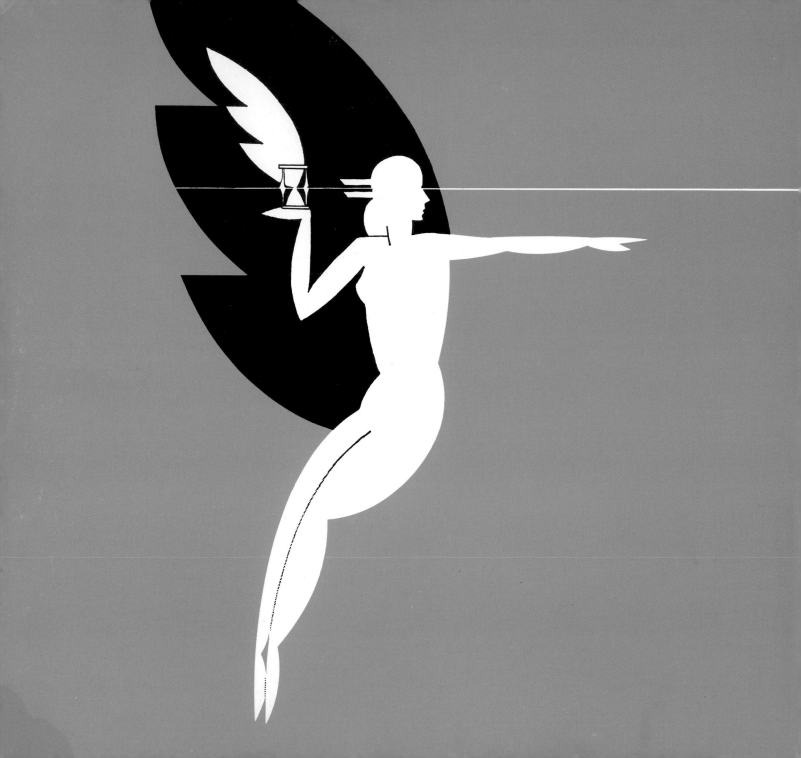

Table of Contents

Introduction

The earliest British trademarks, dating from the 15th Century, were merchants' marks used in commerce and trade. Applied to articles offered for sale, these symbols generally consisted of a monogram or emblem, often combined with a visual pun of the individual's name. A variety of craftsmen, from stone mason to goldsmith, utilized these marks to authenticate the source of origin.

In the 1600s, as travelling merchants were replaced by fixed houses of trade, their marks of identification were substituted by shop signboards. At first these signs consisted of simple pictorial representations of the trade carried on within: a knife for a cutler or a hand for a glover. As time progressed and business became more competitive, the imagery became more complex. In 1803 a traveller wrote about London:

> "As it is one of the secrets of the trade to attract the attention of that tide of people which is constantly ebbing and flowing in the streets, it may easily be conceived that great pains are taken to give a striking form to the signs and devices hanging out before their shops."

1. Merchant mark for John Belton, English goldsmith, c. 1525.

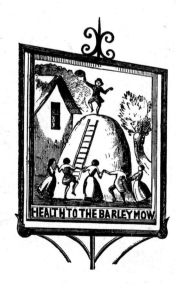

2. Barley Mow tavern signboard from the 1700s.

3. 'Whistling Oyster,' a Drury Lane signboard illustration of 1820.

4. 'Trusty Servant' and 'Hog in Armour.' c. 1700.

In true competitive fashion, shops, inns and taverns consistently attempted to outdo their rivals, often with imaginative results. The *Cat in the Basket* signboard used by a merchant on the Thames actually consisted of a living cat hanging in a basket above the shop. It was quickly copied by other merchants, forcing the shop owner to label his as the *Original Cat in the Basket*. Humor and satire were typically an undercurrent, if not the intent, in many signboard designs. *The Hog in Armour, Puss in Boots* (later the *Jackass in Boots*) and the *Ape and Bagpipes* were all sign illustrations reflecting the humor of animals performing human actions or dressed in human garments.

Just as with merchants' marks, puns on a proprietor's name were commonplace, such as with a picture of a *Hand and Cock* for a shop owned by a Mr. Hancock. When a tobacconist named Farr used the advertising slogan ''Finest Tobacco by Farr'' on his tobacco papers and shop signboard, he was not only describing the quality of his tobacco but successfully expressing his tongue-in-cheek sense of humor. This unique British wit is a common theme throughout subsequent decades of trademark design.

The printed trade card, forerunner of today's business card, was popularized throughout the 19th Century. Besides carrying the name and address of the merchant, an advertising illustration similar to that used on signboards was incorporated into the design. Great progress was being made in manufacturing industries during the 1800s, and it was com-

mon at this time for many of these companies to develop some sort of identifying mark. Typically these were simply pictures of the product the industry produced, reflecting a thriving export trade to non-English speaking countries. The illustration was readily understood without typography. For the home market, ornamental lettering was added, often in conjunction with engraved borders of flowery decoration. While reflecting the high point of Victorian design, these trademarks were rarely remarkable.

As industry flourished, the need became apparent for a method of registering the identifying marks of a growing number of competing industries. The Trade Marks Act of 1875 initiated a system of registration whereby a manufacturer could make exclusive claim to marks appearing on mass-produced goods. These were published in the *Trade Marks Journal*, which has appeared regularly since May 3, 1876.

With the rise in popularity of packaged goods in retail trade, entire label designs were often registered as trademarks to prevent copying by competitors. Many were labels for patent medicines and food, bearing the signature of a real (or presumably real) individual who attested to the product's authenticity. This use of hand-rendered typography as a unique identifying mark for a company or product has become a traditional device in trademark design.

Interestingly, some of the labels which appeared in the first volume of the *Trade Marks Journal* are for goods still in use

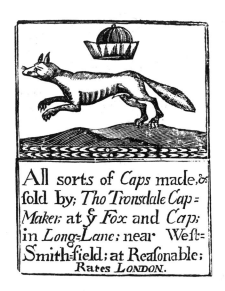

5. Trade card for a cap maker, c. 1740.

6. Typical of Victorian era design is this trademark for 'World Wide' flexible metal window cleaner.

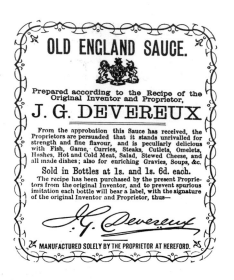

7. A label for 'Old England Sauce,' registered
as a trademark and bearing the signature
of its inventor and original proprietor to
"prevent spurious imitation."

8. 19th Century trademark for fly papers,
advertising itself in two spots as being 'up-to-date.'

today. The "Bass Ale" and "Lea and Perrin's Worcestershire Sauce" labels are the most notable examples, having undergone little change over the past century.

By 1900 the number of trademarks registered per year had reached 10,000. Besides marks and labels, advertisements for a variety of goods were registered. Reflecting the advancement of new industries, products depicted broadened to include motorcars, electric lamps, telegraphic instruments, typewriters and talking machines. With the perfection of engraving and printing technology, the pictorial designs became more complex, as well as generally poorer in quality. It wasn't until the 1920s that British trademark designers were capable of achieving a clarity of form and simplicity of message which would elevate their work above that of ordinary drawing.

A number of factors were responsible for effecting this shift in direction. Foremost was the promotion of good design in Britain during the first two decades of this century. One individual, more than any other, championed good design as being good for business.

Frank Pick, working as managing director of the Underground Group of Companies, ranked publicity as integral to the "public face" of an organization, and the pictorial poster as a key method of promotion. From 1912 onward, Pick hired talented British designers, as well as the young American Edward McKnight Kauffer, to design posters for the London Underground subway system.

In 1916 he commissioned the calligrapher Edward Johnston to design a completely new alphabet for London Transport. Originally intended as a poster typeface, it was quickly adopted for all official London Transport communications, including signs and notices. Johnston redesigned the Underground symbol in 1935, adapting the wheel mark of the original General Omnibus Company.

The English revival of excellence in printing and typography at this time facilitated the spread of quality design into advertising and industry. Harold Curwen, founder of the Curwen Press at Plaistow, was one of the first to employ commercial artists to upgrade all aspects of publicity emanating from his shop. Stanley Morison, working as an advisor to the Monotype Corporation, revived classical typefaces such as Baskerville, Garamond and Bembo, while at the same time promoted the contemporary typefaces Perpetua and Times New Roman. Numerous private presses and commercial printers throughout England restored a sense of elegance and refinement to the graphics of this era.

Advertising agencies recognized the positive impact on sales which clarity in design could achieve. Not oblivious to the excellence of the London Transport posters with which their clients' publicity would have to compete, a shift occurred away from the previously popular Victorian illustrative style. Such notable designers as Tom Purvis and Clive Gardner were commissioned by the W.S. Crawford agency, among others, to create compellingly modern poster images.

ABCDEFGHIJKLMN
OPQRSTUVWXYZ
abcdefghijklmnopqr
stuvwxyz

9. The sans serif typeface designed in 1916 by Edward Johnston for London Transport.

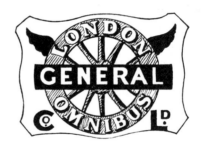

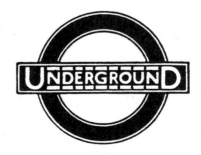

10. The original General Omnibus wheel mark and Edward Johnston's adaptation of it for the Underground symbol, 1935.

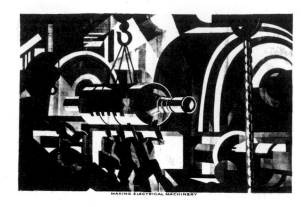

MAKING ELECTRICAL MACHINERY

11. Poster for the Empire Marketing Board, designed by Clive Gardiner in 1930.

12. Trademark for Materna Kakao, designed by Karl Schulpig in 1923.

This new sophistication in design was developing elsewhere in Europe. Germans were making great progress in the area of trademark design; their work in the 1920s is particularly notable for its severe, uncluttered geometry. The stark creations of men such as Karl Schulpig influenced a generation of British designers who were introduced to these new methods of expression via advertising and print journals.

The trademark designs emanating from Britain during the 1920s generally did not attain the level of severity of their German counterparts, in part reflecting the differences in the two societies. The British symbols are best described as humane; while German designers emphasized form, British designers stressed content.

Sadly, most of these trademark designers worked in anonymity as staff or freelance artists in the employ of job printers and advertising agencies. One individual who did receive widespread recognition was Reynolds Stone, a graduate apprentice in 1931 at the Cambridge University Press. Working briefly for Eric Gill, he learned how to engrave in wood. From 1934 on, Stone specialized as an engraver, cutting letterheads and bookplates for private patrons.

It was at this time that he entered the area of trademark design, creating symbols for publishers, printers and paper merchants. His work encompassed numerous graphic design projects, from wine labels to book illustrations, all utilizing the precise cutting of typography and image in wood. It was the successful use of engraving by Stone and others which led

to the popularization of scratchboard and linocuts by so many commercial artists in the 1930s.

The expressive nature of publicity during this decade of economic depression can be attributed in part to the migration of fine artists into the service of industry. Due to the adverse economy, painters, sculptors and printmakers sought employment in the design professions. This era, prior to England's involvement in the war, is characterized by a blurring of the distinctions between fine and commercial art. As a result, the graphic imagery emanating from the 1930s is notable for its remarkable strength and competency.

Professor Richard Guyatt, in a lecture at the Royal College of Art in 1950, analyzed this quality in design as the distinction of "head, heart and hand." The head provides the logic, the heart gives the emotional stimulus to the design and the hand actually gives it its form. These three factors are so interrelated that the viewer is unaware of them in a successful design.

The "head, heart and hand" are certainly in evidence in the designs presented in this collection. Highlighting the best of British trademarks of the 1920s and 1930s, these symbols are a footnote to English society: its dignity and determination, respect for the past and faith in the future. Rarely in the fifty years that followed did trademarks exhibit such a refreshing sense of personality.

13. Two symbol designs by Reynolds Stone, c. 1935. Both are indicative of his wood engraving style.

14. Illustration from an advertisement for Chrysler Motors Limited by the W.S. Crawford agency, 1931. The artist is Ashley Havinden.

People

Leslie Charteris
St. George's Hill, Weybridge, Surrey
Books, 1935

The Somerset Cider Stores
Mill Street, Glastonbury, Somerset
Cider merchant, 1929

British Canners, Limited
Drayton House, Euston Road, London W.C.1
Canned food, 1932

Dean & Company, Limited
Cheadle Heath Works, Stockport, Cheshire
Printing ink, 1926

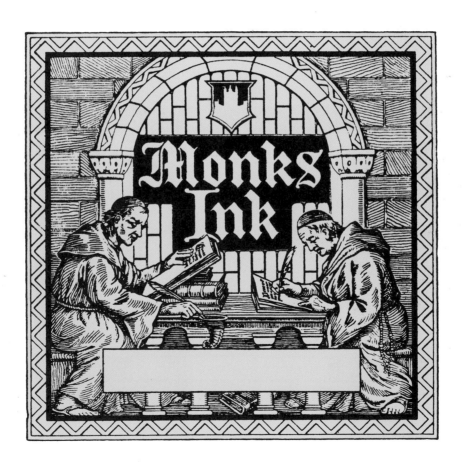

Jones Stroud & Company, Limited
New Street, Long Eaton, Derbyshire
Manufactured goods, 1929

Carrs Limited
3-7 Southampton Street, London W.C.2
Fermented liquors and spirits, 1925

F.J. Hunt & Company, Limited
Bow Bridge Soap Works, High Street, Stratford, London E.15
Common soap, 1922

Mains & Allied Radio Supplies, Limited
41-43 Baker Street, London W.1.
Wireless telephonic apparatus, 1933

Laboratoire Scientifique
81 Lichfield Grove, Finchley, London N.3
Perfumes, 1925

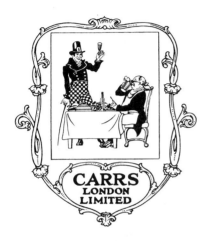

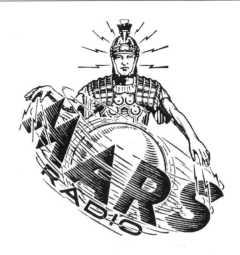

F.J. Hunt & Company, Limited
High Street, Stratford, London E.15
Common soap, 1922

Baker & Company, Limited
Victoria Road, Stroke-on-Trent, Staffordshire
Earthenware and porcelain, 1922

Patons & Baldwins, Limited
Clark Bridge Mills, Halifax, Yorkshire
Yarns of wool, worsted or hair, 1932

Leopold & Victor Hyman
4 Frognal Lane, London N.W.3
Clothing merchants, 1928

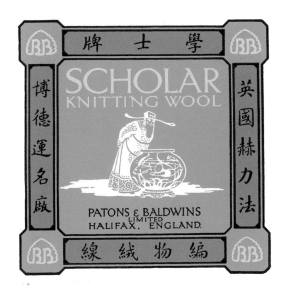

The Chatwood Safe & Engineering Company
Shrewsbury
Safes and security equipment, c. 1947

The Services Watch Company, Limited
37 Belvoir Street, Leicester
Clocks and watches, 1929

Albert & Henry Bassat, Limited
28-37 Easton Street, London W.C.1
Safety razor blades, 1936

Robert Ross & Company, Limited
2 Albion Terrace, Southampton
Games, 1934

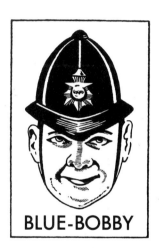

BLUE-BOBBY

Robert Douglas Limited
21 New Bond Street, London W.1
Paper and stationery, 1931

The Renovating Company
38 Carlton Street, Nottingham
Cleaners and dyers of clothing, 1927

The Lancashire Confectionery Company
1 Lear Road, Liverpool, Lancashire
Confectionery manufacturer, 1923

Leeds & Wakefield Breweries, Limited
Plum Street, Leeds
Ale brewers and bottlers, 1936

Whitgib's Fool Fudge
15 Francis Street, Leicester
Confectionery manufacturers, 1927

Marcus Harris & Lewis, Limited
25 Charring Cross, London E.C.1
Fireworks merchants, 1925

Max Spitzer
16 & 17 Devonshire Square, London E.C.2
Tile merchant, 1927

Co-operative Wholesale Society, Limited
1 Balloon Street, Manchester
Electric motors and machinery, 1939

Caribonum Limited
Laura Road, Leyton, London E.10
Ink and carbon papers, 1949

The Nugget Polish Company, Limited
139 Vauxhall Street, Kennington, London S.E. 11
Polishing and cleaning preparations, 1926

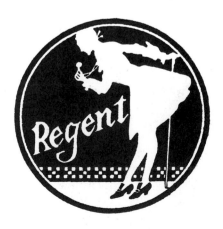

Morris & Jones, Limited
82-84 Whitechapel, Liverpool
Tea merchants, 1928

The Imperial Tobacco Company Limited
East Street, Bedminster, Bristol
Manufactured tobacco, 1927

Illustrated Newspapers Limited
London
Advertising mark, 1929

Henry Edwards & Son, Limited
Hofland Road, London W.14
Cheese, 1936

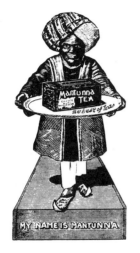

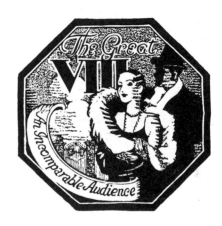

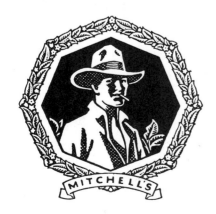

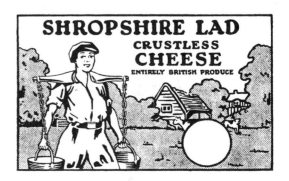

Bryant & May, Limited
Fairfield Works, Bow, London E.3
Matches, 1932

Phillips' Patents Limited
142-146 Old Street, London E.C.1
Rubber plates for the soles of shoes, 1928

Vine Products Limited
London
Wine merchants, c. 1932

S.H. Hargraves Limited
3 Grays Yard, James Street, London W.1
Labels and tickets, 1939

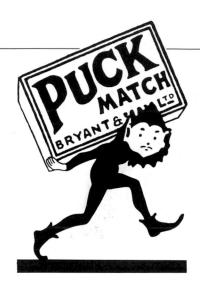

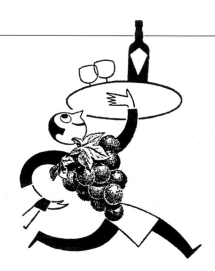

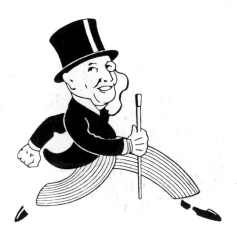

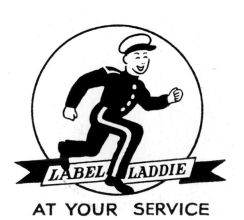

A. Garcia Espana Sociedad Limited
101 Leadenhall Street, London E.C.3
Fresh fruits, 1939

G.A. Pashley & Company, Limited
68 Havelock Street, Loughborough, Leicestershire
Manufacturers of mineral water, 1935

Peter Lunt & Company, Limited
Park Lane, Aintree, Liverpool
Soap manufacturers, 1927

Berners Radio, Limited
Great West Road, Brentford, Middlesex
Wireless telephonic apparatus, 1937

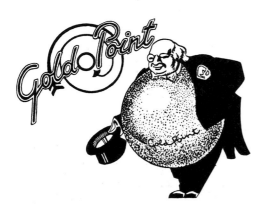

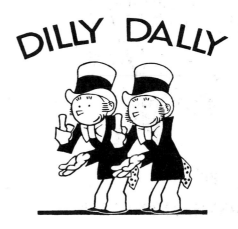

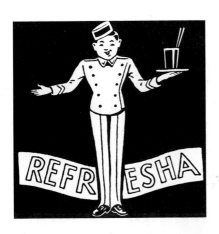

Albert & Henry Bassat Limited
28-37 Easton Street, Roseberry Avenue, London W.C. 1
Razor blades, 1934

Cohen & Wilks, Limited
Derby Street, Cheetham, Manchester
Clothing manufacturer, 1923

Beverlys Limited
2B Acker's Place, Chorlton-on-Medlock, Manchester
A cocktail, 1936

Edwin Thomas & Company, Limited
34 Upper Thames Street, London E.C.4
Printing and writing papers, 1931

The Services Watch Company, Limited
37 Belvoir Street, Leicester
Clocks and watches, 1931

The Services Watch Company, Limited
37 Belvoir Street, Leicester
Clocks and watches, 1931

The Services Watch Company, Limited
37 Belvoir Street, Leicester
Clocks and watches, 1931

Exide Batteries
Clifton Junction, near Manchester
''The Starter'' long life battery, c. 1928

Exhibition of Industrial Art
14 Oxford Street, Manchester
Exhibition symbol designed by A. Paxton Chadwick, 1930

Gerrish, Ames & Simpkins, Limited
63 Carter Lane, London E.C.4
Articles of clothing, 1928

I. & E. Nelson & Company, Limited
Parkside Road, Sale, Cheshire
Articles of clothing, 1927

John A. Hunter & Company, Limited
Broad Green Road, Liverpool
Substances used as food or ingredients in food, 1935

Veterinary Product Company
8 King Street Mews, Belfast, Northern Ireland
Veterinary preparations, 1933

Gallops Shoe Repair Service Limited
4 Bute Street, London S.W.7
Boots and shoes, 1934

Pirelli Limited
343 & 345 Euston Road, London N.W.1
India-rubber tyres, 1931

Highfield Boot Company, Limited
Thrapston Road, Finedon, Northamptonshire
Boots, shoes and slippers, 1928

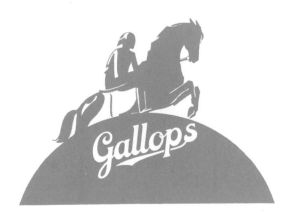

Mensana Limited
10-12 Cork Street, London W.1
Cinema and theatre publications, 1935

British Hanovia Quartz Company, Limited
Trading Estate, Bedford Avenue, Slough
Quartz lamps for medical use, 1925

C.H. Leng & Sons
Fordhouse Lane, Stirchley, Birmingham
Metal brushes, 1930

Finsler & Company, Limited
9 Great Tower Street, London E.C.3
Preserved fruits, 1934

Williams Limited
Goodman Street, Birmingham
Manufactured aluminum articles, 1928

August Lannoye
65 Victoria Street, London S.W.1
Floor coverings, 1930

London Spinning Company, Limited
Trundley's Road, Deptford, London S.E.8
Ropes, twine and cordage, 1938

Finmar Limited
44 Ranelagh Road, Victoria, London S.W.1
Furniture and upholstery, 1936

Lysaght Protected Steel Company Limited
St. Vincent's Iron Works, Bristol
Roofing material, 1933

Periodical Distributors Limited
181 Upper Thames Street, London E.C.4
Periodical publications, 1934

William Jessop & Sons Limited
Brightside Works, Brightside Lane, Brightside, Sheffield
Gas turbine discs, blades and rotors, 1939

National Accumulator Company, Limited
50 Grosvenor Gardens, London S.W.1
Electrical equipment, 1930

The Valentine Varnish & Lacquer Company, Limited
Colham Mill Road, West Drayton, Middlesex
Paints and varnishes, 1939

George Mason & Company, Limited
265 Merton Road, Southfields, London S.W.18
Sauces and jellies, 1934

The Central Motor Coach Works
76 Fountainbridge, Edinburgh
Cellulose paint for vehicle bodies, 1928

The Mervyn Coal Company Limited
Eagle House, Cannon Street, London E.C.4
Coal merchants, 1936

Sandeman, Sons & Company, Limited
20 St. Swithins Lane, London E.C.4
Wines and spirits, 1930

John Jameson & Son, Limited
Dublin, Ireland
Seven year old whiskey, c. 1928

Ferguson Edwards Limited
Abbey Road, Barking, Essex
Paints and varnishes, c. 1935

John Drew & Sons, Limited
Grosvenor Road, Perry Barr, Birmingham
Flour, bread, cakes and biscuits, 1929

Max Michael Kay
58 Daisy Bank Road, Victoria Park, Manchester
Cotton piece goods, 1928

Smith Brothers Limited
46 Bunnian Place, Basingstoke, Hampshire
Agricultural and horticultural seeds, 1928

Thomas Hardcastle & Son, Limited
Firwood Lane, Tonge Moor Road, Bolton
Bleached cotton piece goods, 1928

Smith & Company
132 Borough, London S.E.1
Oils prepared for toilet purposes, 1933

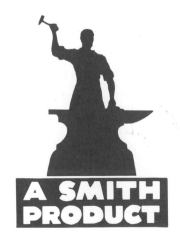

Oxley Engineering Company Limited
Clarence Road, Hunslet, Leeds
Chemical and structural engineers, 1939

B. Petronzio & Sons
Paramount Works, Tyndale Place, London N.1
Furniture, 1931

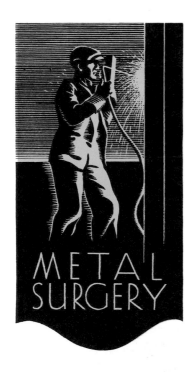

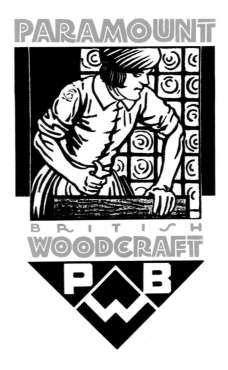

J. Walsh and Sons, Limited
72 & 76 Northgate, Blackburn, Lancashire
Pianos, 1929

The Continental and Overseas Trust, Limited
20 Bucklersbury, London E.C.4
Film producers, 1929

The Lace Web Spring Company, Limited
Cross Street, Sandiacre, near Nottingham
Furniture and upholstery, 1929

Beaute Limited
38 Old Bond Street, London W.1
Perfume, 1931

Beret Industries Limited
Fairlie Road, Slough, Buckinghamshire
Berets, 1936

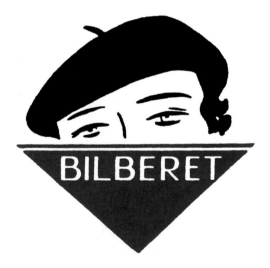

Permal Laboratories
Blundell Street, Hull
Shampoo creams, 1937

Samuel Weinfulk
2 Kensal Place, London W.10
Sachets for use in hair waving, 1939

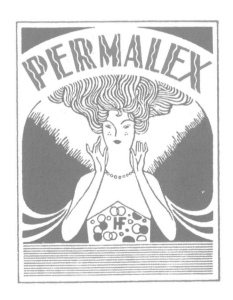

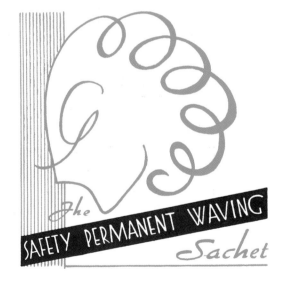

Bendix-Perrot Brakes, Limited
Westwood Road, Witton, Birmingham
Brakes for automobiles, 1929

Swedish Bread Company Limited
1 Laurence Pountney Hill, London E.C.4
Food, 1937

Rayonese Limited
65 Whitworth Street, Manchester
Silk piece goods, 1931

Lady Zoe Caillard
8 West Halkin Street, London S.W.1
Diet tablets, 1931

SWEGENA.

Helen Jardine Artists
Avenue Chambers, Vernon Place, Southampton Row, London W.C.1
Fashion and commercial art, 1929

Tokalon Limited
Chase Road, London N.W.10
Perfume, 1931

Kolster-Brandes, Limited
Cray Works, Sidcup, Kent
Electrical instruments, 1929

The Yorkshire Sales Corporation Limited
Parkwood Mills, Grove Street, Longwood
Woolen blankets, 1935

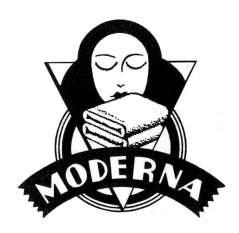

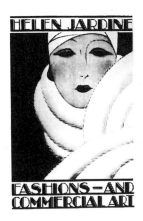

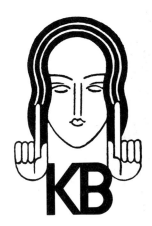

The Bowden Brake Company, Limited
King's Road, Tyseley, Birmingham
Cycles, 1927

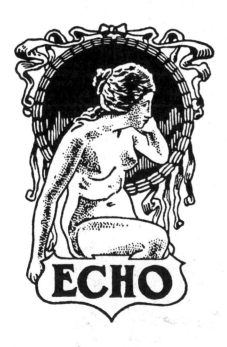

Carreras Limited
Arcadia Works, City Road, London E.C.1
Tobacco, 1928

G. Paul Leonhardt
70-72 Chancery Lane, London W.C.2
Stockings and socks, 1926

Hyman Appleberg
6 Falcon Street, London E.C.1
Stockings and socks, 1927

Mac Fisheries, Limited
Victoria Embankment, Blackfriars, London E.C.4
Fish merchants, 1928

Jacob's Cream Crackers
Aintree, Merryside
Crackers, c. 1928

Victor Drury & Sons, Limited
Worcester Street, Bromsgrove, Worcestershire
Shoes and slippers, 1934

B. Windsor & Sons, Limited
Castle Works, Poulton-le-Fylde, Blackpool
Bathing costumes, 1930

Howes & Jessop Limited
Clinton Street, Leicester
Knitted articles of clothing, 1931

J. & N. Philips & Company, Limited
35 Church Street, Manchester
Bathing suits, 1934

Paul Dufonte, Limited
1a Great Chapel Street, Oxford Street, London W.1
Articles of clothing, 1929

R. Lehmann & Company Limited
Penninsular House, Monument Street, London E.C.3
Common soap flakes, 1932

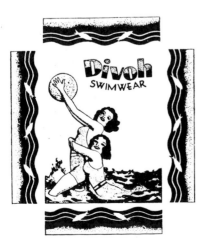

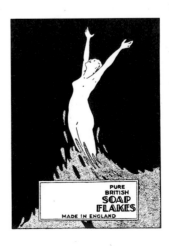

The Scottish Co-Operative Wholesale Society, Limited
95 Morrison Street, Glasgow, Scotland
Breakfast oats, 1925

Percy Bradley
38 Ladypool Road, Birmingham
Beef suet, 1929

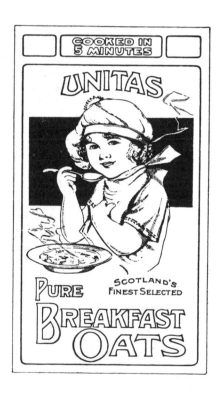

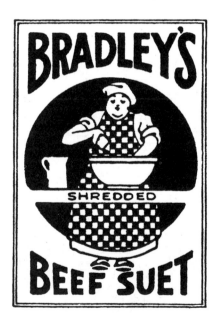

Putnam Knitting Company
57-60 Holborn Viaduct, London E.C.1
Dish cloths and towels, 1929

The Wonder Washer Company
68 Victoria Street, London S.W.1
Washing machines, 1929

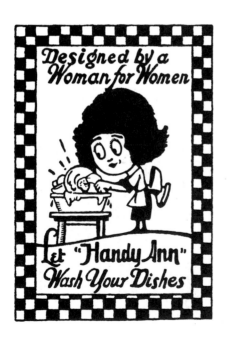

Crystal Products Company Limited
53 Farringdon Road, London E.C.1
Perfume, 1932

Albert Weinberg
33 Newman Street, Oxford Street, London W.1
Cigarettes, 1929

Reckitt & Sons, Limited
Kingston Starch Works, Dansom Lane, Hull
Bath oil, 1931

William Hollins & Company Limited
Castle Boulevard, Nottingham
Articles of clothing, 1931

William Burt Dixon
Shaws, Uppermill, near Oldham
Medicines, 1929

Saymore Confectionery Company
76 Seymour Road, Bolton
Toffee, 1926

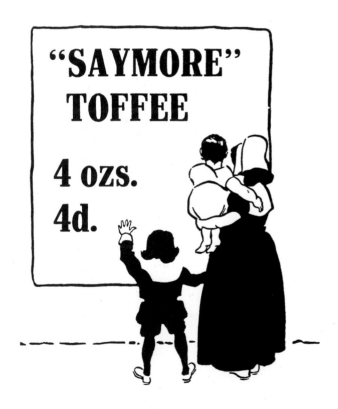

Va-Per-Marcel Limited
Radnor House, 93-97 Regent Street, London W.1
Spools for use in curling the hair, 1932

Nestle & Company, Limited
48 South Molton Street, London W.1
Hairdressing and hair-waving preparations, 1930

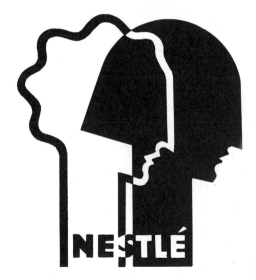

Animals

British Bemberg Limited
Hazel House, Milk Street, London E.C.4
Silks, c. 1930

Porth Textiles Limited
Dinas, Rhondda, Glamorgan
Ribbons, braids and trimmings, 1939

John E. Moss, Limited
22 Ivy Lane, London E.C.4
Bottle wrappers made of tissue paper, 1931

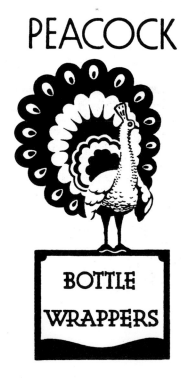

P.A. Batty & Company Limited
21 Neal Street, Covent Garden, London W.C.2
Fruit and produce brokers, 1934

The Electramonic Company, Limited
Bear Gardens, Park Street, Southwark, London S.E.1
Gramaphones and wireless telephonic instruments, 1928

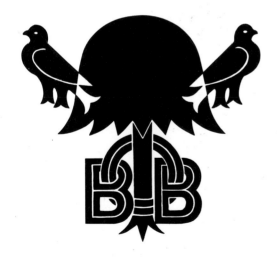

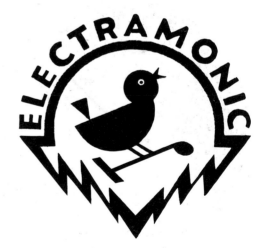

Jeremiah Ambler & Sons, Limited
Midland Mills, Valley Road, Bradford, Yorkshire
Carpets and rugs, 1929

Ashton & Company, Limited
48-49 Redcross Street, Barbican, London E.C.1
Hats, 1923

Soft-Lite Lens Company, Limited
67 Hatton Garden, London E.C.1
Lens blanks, 1936

Cockrill & Rew, Limited
151 Farringdon Road, London E.C.1
Textiles, 1930

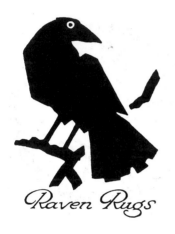

Alfred Benjamin
114-115 Fore Street, London E.C.2
Socks and stockings, 1934

Bookless Brothers Limited
232a Union Street, Aberdeen, Scotland
Dried fish, 1926

Direct Millinery Company, Limited
90 Princess Street, Luton, Bedfordshire
Women's hats, 1925

Brown & Polson, Limited
Carriagehill, Paisley
Corn flour, 1922

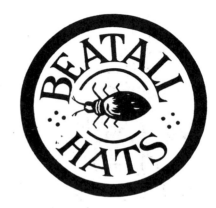

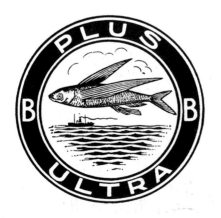

Claude Lipman Lyons
12 Beechcroft Avenue, Golders Green, London N.W.11
Medicated saline preparations for human use, 1935

The Economic Hot Water Supply Company
Ynisdrew Road, Pontardawe, Swansea, Glamorganshire
Geyers for heating water, 1927

Reckitt & Sons, Limited
Kingston Starch Works, Dansom Lane, Yorkshire
Polishing preparations, 1934

The Eastern Manufacturing Company Limited
30 & 32 Ludgate Hill, London E.C.4
Jute yarns and tissues, 1934

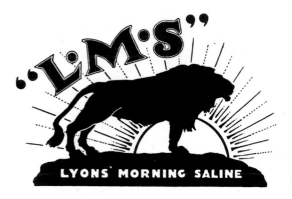

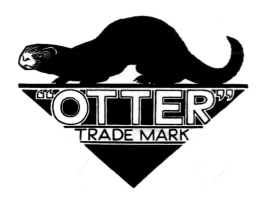

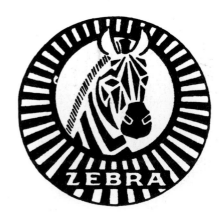

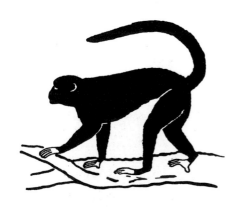

William Sykes, Limited
Westfield Road, Horbury, Yorkshire
Leather outer cases for footballs, 1930

The Eastern Manufacturing Company Limited
30 & 32 Ludgate Hill, London E.C.4
Jute yarns and tissues, 1934

Patons & Baldwins, Limited
Clark Bridge Mills, Halifax, Yorkshire
Yarns of wool, worsted or hair, 1927

J. & J. Colman, Limited
Carrow Works, Norwich
Cornflour and wheat flour, 1929

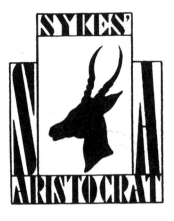

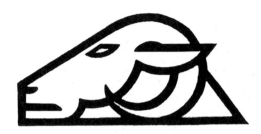

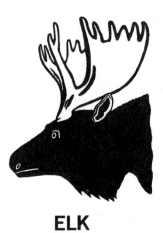

ELK

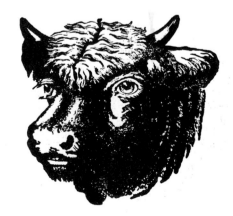

C.H. Leng & Sons
Hazelwell Brush Works, Fordhouse Lane, Stirchley, Birmingham
Brushes and brooms, 1932

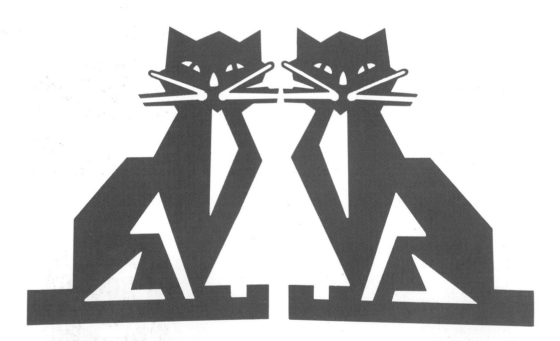

TWINKAT

The Wyvern Fountain Pen Company
143-144 Holborn, London E.C.1
Fountain pens, 1930

G. & G. Kynoch Limited
2 Savile Row, Bond Street, London W.1
Clothing of wool, worsted or hair, 1934

London & Kano Trading Company, Limited
Boundary Works, All Saints, Manchester
Cotton piece goods for export, 1931

Tubbs, Lewis & Company, Limited
29-30 Noble Street, London E.C.2
Elastic sandallings, webs and cords, 1928

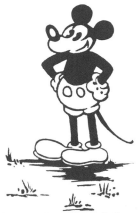

MICKEY MOUSE.

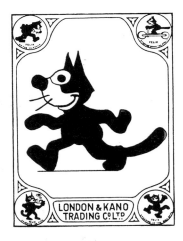

Bleachers' Association, Limited
Blackfriars House, Parsonage, Manchester
Cotton piece goods, 1930

Bleachers' Association, Limited
Blackfriars House, Parsonage, Manchester
Cotton piece goods, 1930

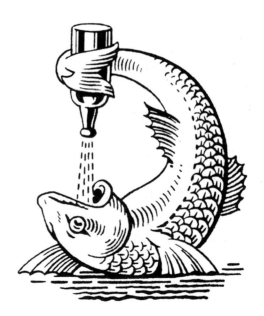

77

G. & G. Kynoch Limited
2 Savile Row, Bond Street, London W.1
Woollen rugs for personal use, 1933

The British Dyewood Company, Limited
86 St. Vincent Street, Glasgow
Tanning materials, 1920

Cash & Carry Limited
New Bridge Street House, New Bridge Street, London E.C.4
Substances used as ingredients in food, 1931

James Buchanan & Company, Limited
26 Holborn, London E.C.1
Whisky, 1935

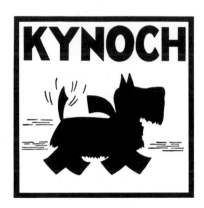

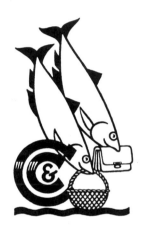

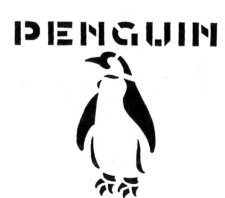

Chappel Brothers Limited
28 Victoria Street, London S.W.1
A meat and cereal food for carnivorous animals, 1927

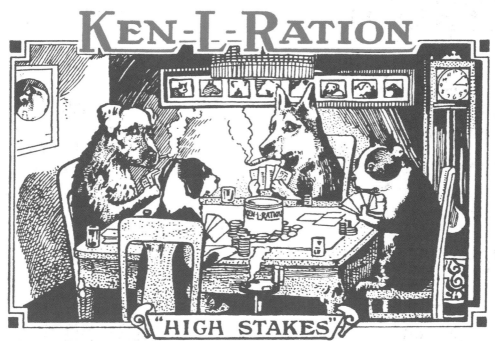

Royal Coat of Arms for the Imperial War Graves Commission
Designed by Reynolds Stone, c. 1935

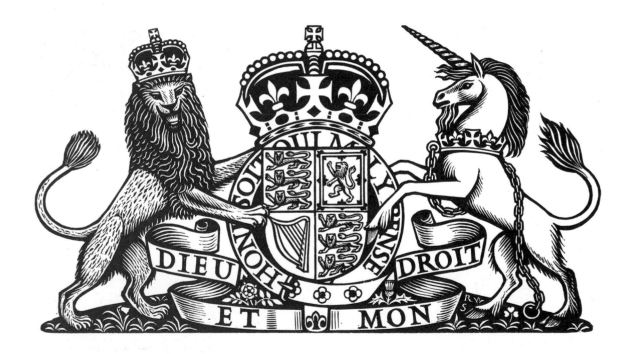

Charles Osborn
80 Moor Street, Birmingham
Light shades and electric light fittings, 1935

Kimberlin Brown & Company, Limited
6 St. Martins, Leicester
Women's blouses, jumpers and dresses, 1926

Richard Johnson & Nephew, Limited
Bradford Ironworks, Forge Lane, Manchester
Barbed wire fencing, 1938

Purnell & Panter, Limited
Hanging Ditch, Manchester
Yeast, pickles, sauces and chutney, 1927

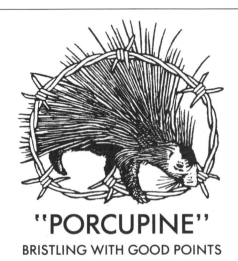

"PORCUPINE"
BRISTLING WITH GOOD POINTS

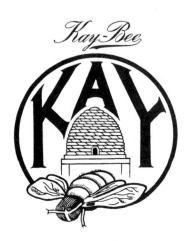

John Dickinson & Company, Limited
Home Park Mills, Kings Langley, Herts
Coated papers and boards, c. 1935

Rolls-Royce Limited
Derby, England
Aircraft engines, c. 1939

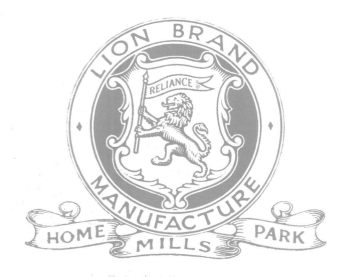

Wilmot-Breeden Limited
Eastern Works, Camden Street, Birmingham
Component parts of automobiles and motorcycles, 1932

The Imperial Tobacco Company, Limited
East Street, Bedminster, Bristol
Manufactured tobacco, 1927

David Dixon & Son Limited
Cardigan Mills, Kirkstall Road, Leeds
Tweeds, 1933

Percy Lund Humphries & Company, Limited
3 Amen Corner, London E.C.4
Fine printing and binding, c. 1930

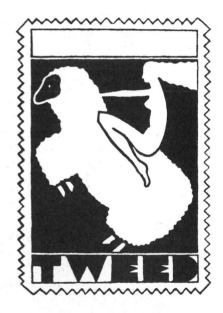

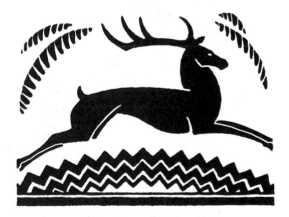

V.L. Churchill & Company Limited
Walnut Tree Walk, Kennington, London S.E.11
Engineering, architectural and building contrivances, 1937

Henry Franc & Lauder Limited
4 Chepstow Street, Manchester
Cotton piece goods, 1935

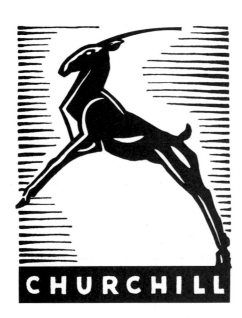

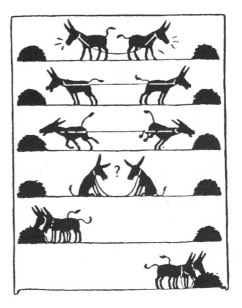

Objects & Typography

George Marie Maudit
6 New Burlington Street, London W.I
Machinery of all kinds, 1929

Filmophone Flexible Records Limited
Broadmead House, Panton Street, London S.W.1
Gramaphone records, 1930

The British Lubricating Research Organization Limited
London
Research involving oil and other lubricants, c. 1930

Gordon Russell Limited
Lygon Cottage, High Street, Broadway, Worcestershire
Furniture, 1929

Turners Asbestos Cement Limited
Trafford Park, Manchester
Asbestos goods, 1931

Levy's Sound Studios, Limited
83 Cannon Street, London E.C.4
Gramaphones and gramaphone records, 1931

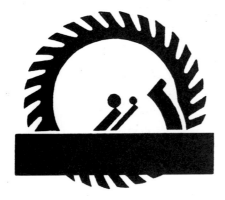

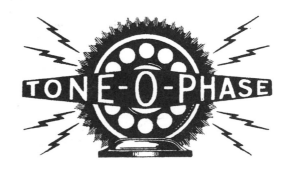

A. Bell & Sons, Limited
64 Espedair, Paisley, Renfrewshire
Articles of clothing, 1934

National Benzole Company, Limited
Wellington House, Buckingham Gate, London S.W.1
Benzole mixture for automobiles, 1930

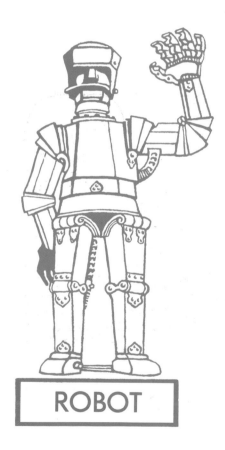

ROBOT

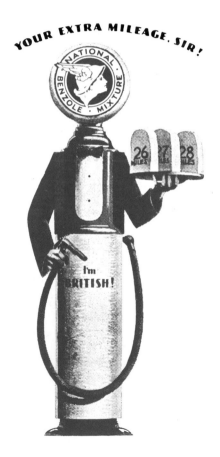

Beckley & Morris
21a Barnsbury Park, Liverpool Road, London N.1
Yeast merchants, 1932

Soag Machinery Company
Juxson Street, Lambeth, London
Printing presses, c. 1935

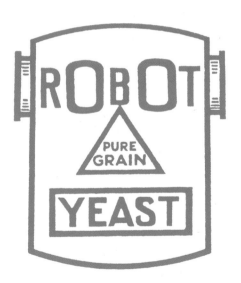

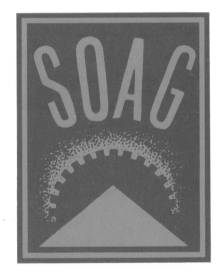

The Isokon Furniture Company
The Isokon Flats, Lawn Road, London N.W.3
Wood furniture, c. 1935

William Mather Limited
Dyer Street Works, Dyer Street, Hulme, Manchester
Medical and surgical plasters for human use, 1925

Nathan Ernstone
61 Blandford Street, Newcastle-upon-Tyne
Men's caps, 1938

Eastern Edibles, Limited
Stourton Lodge, Wakefield Road, Leeds, Yorkshire
Potato crisps, 1925

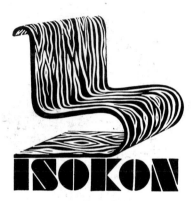

Reckitt & Sons, Limited
Kingston Starch Works, Dansom Lane, Hull, Yorkshire
Starch and blue for laundry purposes, 1933

Radio Communication Company, Limited
34 & 35 Norfolk Street, Strand, London W.C.2
Wireless telegraphy equipment, 1928

W. Holmes & Son, Limited
Newton Lane, Wigston, near Leicester
Boys' and men's stockings, 1935

Frederick Shoesmith & Harold Shoesmith
61 Well Road, Glasgow
Bath salts for toilet use, 1929

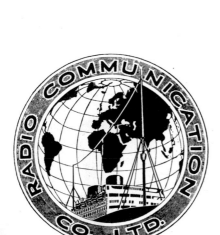

Carter & Smith, Limited
13 Coulston Street, Sheffield
Wholesale grocers, 1924

Lever Brothers Limited
Port Sunlight, England
Kitchen cleanser mark designed by E. McKnight Kauffer, c. 1930

The United Turkey Red Company Limited
46 West George Street, Glasgow
Cotton piece goods, 1934

Tube Products Limited
Popes Lane, Oldbury, Birmingham
Metal furniture, 1934

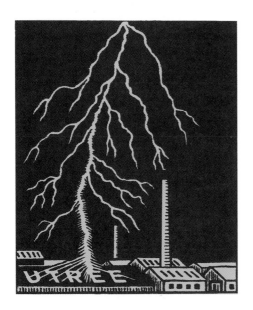

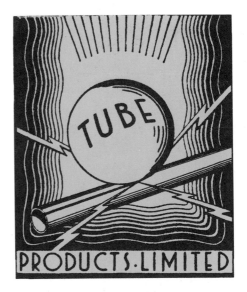

H. Viney & Company Limited
Strand Road, Preston
Paper and cardboard, 1938

T.H. Prosser & Sons, Limited
546-562 Holloway Road, London N.7
Tennis rackets, 1927

Herbert Whitworth Limited
115 Princess Street, Manchester
Agricultural machinery, 1920

Trusound Limited
21 Panton Street, Haymarket, London S.W.1
Gramaphone records, 1931

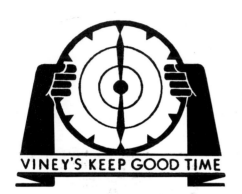

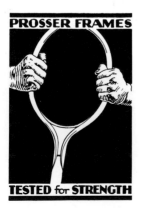

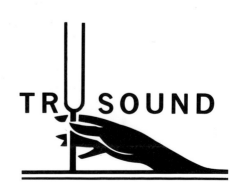

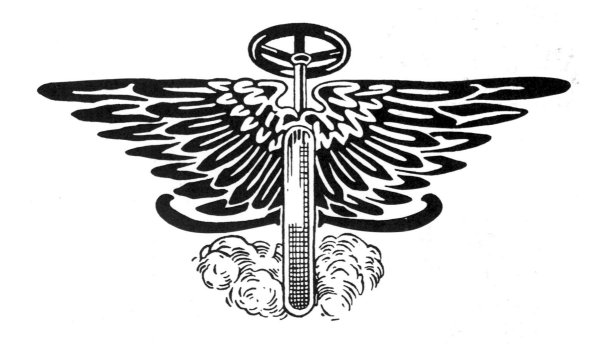

Briggs & Greenwood, Limited
Kirkby Road, Sutton-in-Ashfield
Hosiery and underwear, 1925

William Merrick
Worsley Road, Swinton, Manchester
Raincoats, 1920

Wilkinson & Warburton
46 & 48 West Street, Leeds
Men's clothing, 1920

Ilford Limited
Ilford, London
Photographic papers, c. 1935

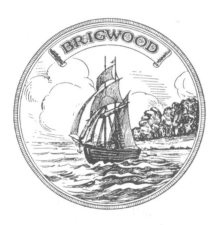

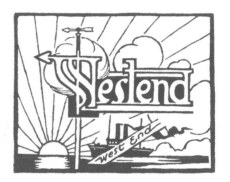

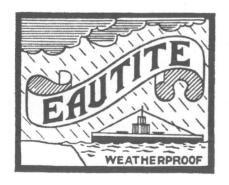

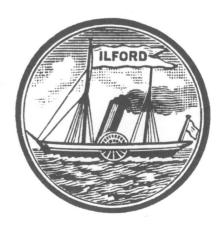

Waterside Clothing Company
Waterside Mills, Market Street, Hebden Bridge, Yorkshire
Articles of clothing, 1931

James Thompson & Sons, Limited
Bagot Mills, 7 Aston Road North, Birmingham
Dried peas, c. 1935

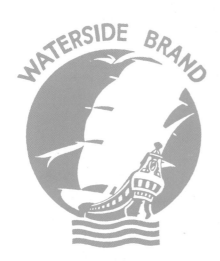

Selincourt & Sons, Limited
3 Vere Street, London W.1
Ladies' coats and suits, 1936

Mac Fisheries, Limited
30/34 New Bridge Street, London E.C.4
Preserved fish, fruit and meats, 1930

Ashton Brothers & Company, Limited
29 Portland Street, Manchester
Bed sheets, blankets and pillow cases, 1939

Davidson, Unwin & Company
108 Palmerston House, Old Broad Street, London E.C.2
Oranges grown in Brazil, 1929

Cousen, Hughes & Company, Limited
28 East Parade, Bradford, Yorkshire
Piece goods of wool, worsted or hair, 1929

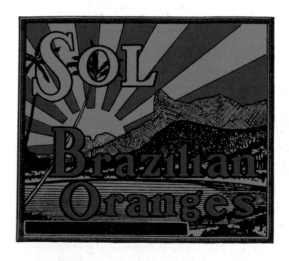

Maurice Goualin Limited
49 Albert Hall Mansions, Kensington Gore, London S.W.7
Piece goods wholly or principally of cotton, c. 1935

R.T. Jackson & Company, Limited
171 & 172 Picadilly, London W.1
Wine merchants, 1931

British Lion Film Corporation
76-78 Wardour Street, London W.1
Cinematograph films, 1939

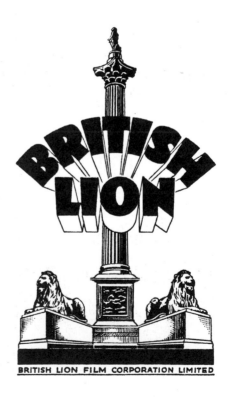

Haigh & Sons, Limited
Norwood Mill, Southall, Middlesex
Picture and photograph frames, 1929

David Sassoon & Company, Limited
Orient House, 67 Granby Row, Manchester
Yarns for export to China, 1929

London Passenger Transport Board
55 Broadway, Westminster, London S.W.1
Transport buildings, 1935

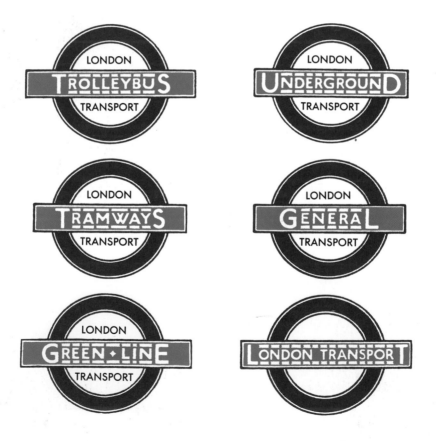

Kattenburgs Limited
45 Julia Street, Strangeways, Manchester
Waterproof coats, capes, trousers and overalls, 1938

Plowman, Barrett & Company, Limited
87 Wandsworth Road, South Lambeth, London S.W.8
Jams, marmalade and tinned fruit, 1924

Tilers Limited
Haigh Park Road, Stourton, Leeds
Roofing tiles made of concrete, 1931

Souplex Limited
Westgate, Morecambe
Safety razor blades, 1930

Benjamin Sykes & Sons, Limited
107, 109 & 111 Brownlow Hill, Liverpool
Bread, 1925

The Scottish Co-operative Wholesale Society, Limited
95 Morrison Street, Glasgow
Margarine, 1925

Ashton Brothers & Company, Limited
29 Portland Street, Manchester
Bed sheets, blankets and pillowcases, 1939

Donald Brothers Limited
287 Regent Street, London W.1
Fabrics, c. 1935

The Welsh Land Settlement Society Limited
56 Principality Buildings, Queen Street, Cardiff
Fresh fruits and vegetables, 1938

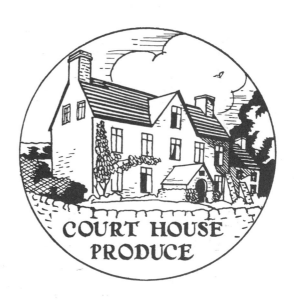

Harrods Limited
87-135 Brompton Road, London S.W.1
Jams, jellies and preserves, 1927

Tamara Limited
8 New Court, Lincoln's Inn, London W.C.2
Perfume, 1932

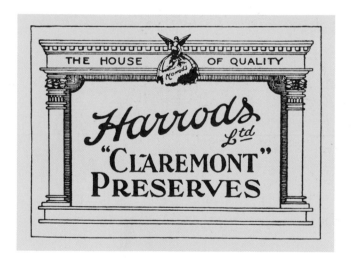

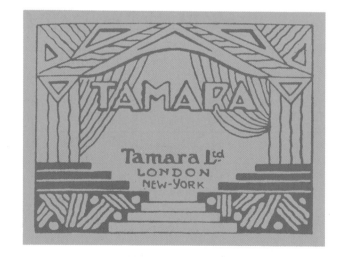

Harry Morris Coverdale
40 Friar Lane, Leicester
Articles of clothing, 1934

PYLON

Keen, Robinson & Company, Limited
New Century Factory, Denmark Street, London E.1
Oats grown in Great Britain, 1922

J. Nuttall & Sons
Pigeon Street Mills, Ducie Street, Manchester
Self-raising flour, 1925

The Pentan Company
38, 40 & 45 James Street, Cardiff
Self-raising flour, 1926

The Chester Northgate Brewery Company, Limited
The Brewery, Northgate, Chester
Ale, 1923

John Wood
21 High Street, Perth, Scotland
Biscuits and shortbread, 1927

The British Patent Perforated Paper Company, Limited
Atlas Works, Berkshire Road, Hackney Wick, London E.9
Medicated toilet paper, 1933

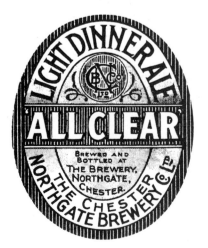

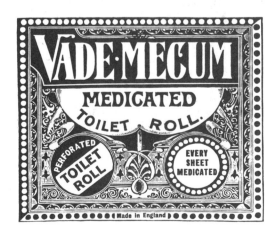

Lawson & Smith
33 Quality Street, Leith, Scotland
Whiskey, 1929

Rowntree & Company, Limited
The Cocoa Works, Wigginton Road, York, Yorkshire
Cocoa, chocolate and confectionery, 1926

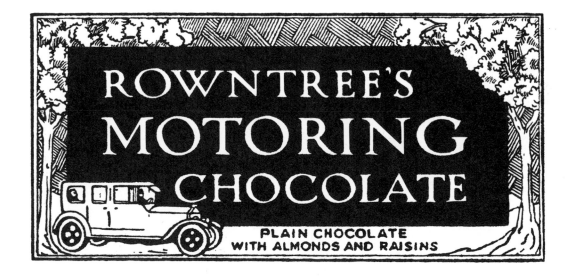

Edward Bates & Sons
Cunard Building, Pier Head, Liverpool
Cotton piece goods for export to India, 1926

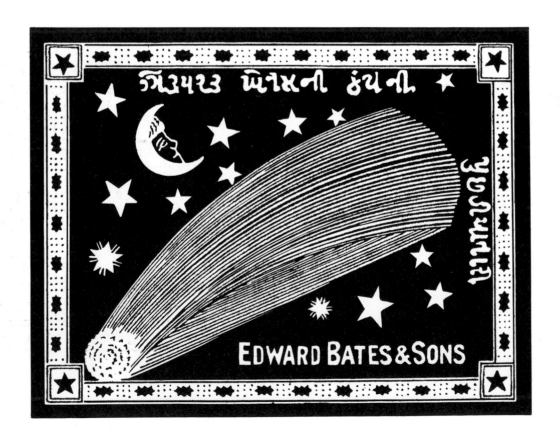

Henry Mallet & Sons
35 & 37 St. Mary's Gate, Nottingham
Lace curtains, nets and bedcovers, 1931

Blackwood, Blackwood & Company
101 Olive Street, Calcutta, India
Cotton piece goods, 1925
"The Sanskrit character repeated in the centre of the Mark and at each corner represents the three Hindoo Godheads, 'Bishnu, Rudra and Brama.'"

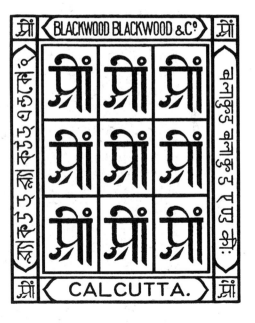

Candy & Company, Limited
Devon House, 60 Berners Street, London W.1
The ''Devon Fire'' fireplaces, c. 1930

The Witchampton By-Products, Limited
Witchampton, near Wimborne, Dorset
Firelighters, 1932

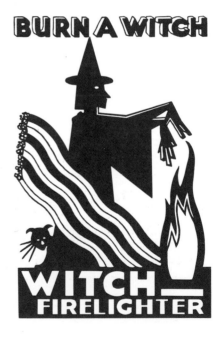

Hewson Price Limited
170 Westminster Bridge Road, London S.E.1
Printed publications, 1933

Elizabeth Arden Limited
5 Cork Street, London W.1
Cosmetics cointainers, 1933

O.H. Limited
8 Hatton Yard, Hatton Garden, London E.C.1
Chimney pots, caps and cowls of earthenware, 1936

Steam Plant Accessories, Limited
38 Victoria Street, London S.W.1
Metal goods, 1932

Henry Hope & Sons, Limited
Smethwick, Birmingham
Metal windows and fascias, c. 1938

The Ellis Chemical Company, Limited
15 East Street, Leicester
Fertilizers, 1931

The Cresols & General Antiseptics Company
6 Hardwidge Street, Snow's Fields, Bermondsey, London S.E.1
Disinfectants, 1922

Bridcut Harries & Company
70 Mortimer Street, London W.1
Articles of clothing, 1925

The Morris Garages, Limited
36-37 Queen Street, Oxford
Motor cars, 1928

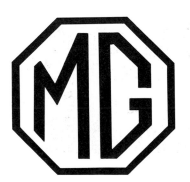

The Creamola Food Products, Limited
Creamola Works, 196 Clyde Street, Glasgow C.1
A preparation in crystal form for making a beverage, 1931

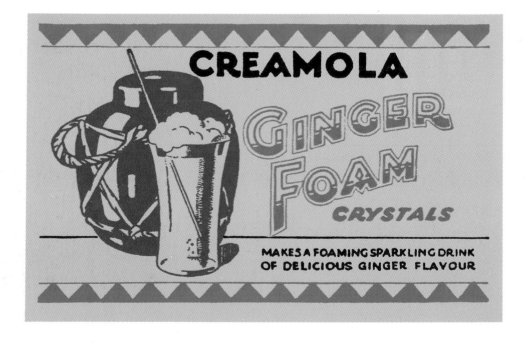

Harvey & Company
10 & 12 Pentonville Road, London N.1
Tobacco, 1922

Advance Laundries Limited
118/132 New Oxford Street, London W.C.1
Laundered articles of clothing, 1938

Bibliography

A Century of Trademarks
Patent Office, Great Britain: London, 1976

Graphic Design
John Lewis
Routledge & K. Paul: London, 1954

Modern Publicity
Edited by F.A. Mercer and W. Grant
The Studio Limited: London, 1930 & 1931

Symbols: Signs and their Meaning and Uses in Design
Arnold Whittick
Charles T. Branford Company: Newton, Massachusetts, 1960

Thirties: British Art and Design Before the War
Edited by Jennifer Hawkins and Marianne Hollis
Arts Council of Great Britain: London, 1970

The Typography of Newspaper Advertisements
Francis Meynell
Ernest Benn Limited: London, 1929

Index